HOME GUARD MANUAL OF
CAMOUFLAGE

HOME GUARD MANUAL OF
CAMOUFLAGE

By
ROLAND PENROSE

Lecturer to the War Office School for Instructors
to the Home Guard
Formerly lecturer at the Osterley Park School for
Training of the Home Guard

Illustrated

LONDON
GEORGE ROUTLEDGE & SONS, LTD.
BROADWAY HOUSE: 68–74 CARTER LANE, E.C.

First published	•	*October 1941*
Second impression	•	*October 1941*
Third impression	•	*December 1941*
Fourth impression	•	*March 1942*
Fifth impression	•	*April 1942*

Printed in Great Britain by Butler & Tanner Ltd., Frome and London

Sixth impression • *March 2022*

ISBN: 978-0-953238-97-2

This edition published by Lee Miller Archives Publishing
Origination by Unicorn Publishing Group

Printed by Gutenberg Press, Malta

CONTENTS

AUTHOR'S NOTE

THE suggestions set out in this Manual have been gathered from many different sources. The author makes no claim to their originality. Many of them are as old as warfare itself, others are due to the generous collaboration of members of the Home Guard and the invaluable instruction given at the Camouflage Development and Training Centre, R.E.

HOME GUARD
MANUAL OF CAMOUFLAGE

CHAPTER I

THE NECESSITY FOR CAMOUFLAGE

WHY has camouflage gained such importance in
modern blitzkrieg warfare? To answer this
question we must consider the changes that have
taken place in the methods of warfare. There
can be no doubt that in all fighting, however
primitive or however complex it may be, sur-
prise and deception of the enemy are among the
most important means of gaining an advantage
over him. They may in cases where the odds
are heavily in favour of one of the opponents
still be the principal factor in turning the scales
against him. There are many instances of battles
where deception by feint attacks or retreats and
the ingenious use of bluff have won the day for
the weaker side when from every other con-
sideration they were certain to be defeated. In
fact, strategy has used camouflage as one of its

most valuable weapons. But in order that decep-
tion and surprise shall achieve their maximum
result the enemy must be kept ignorant of our
actual intentions. This means that we must
conceal from him our motives as well as our
vital resources which we cannot afford to lose.

However, the tendency in warfare up to very
recent times has been to rely on sheer strength
and even ostentation rather than on conceal-
ment. The war dance and paint of savages, the
shining armour and plumes of medieval knights,
the scarlet coats and fantastic headgear of more
recent times were a means of striking terror into
the heart of the enemy. They were a kind of
camouflage in reverse, a display of strength
designed to demoralise him, perhaps even with-
out striking a blow. The parallel of these
methods can be found in nature. There are
many instances that could be quoted ; perhaps
the most striking is that of the frilled lizard
who, although unable to put up a fight, manages
to intimidate his enemies by puffing out a large
frill round his neck and hissing ferociously through
his widely opened jaw. Fortifications such as
the medieval castle have shown the same ten-
dency. The bigger and the more forbidding
the walls, the safer was the garrison. Even that
unwarlike animal, the elephant, could be pressed

into service in the early days of what we now call the war of nerves. In fact, the very nature of fortresses, whether they were constructed with walls, earthworks or trenches, made them difficult to hide, and in consequence display was a more fruitful method of gaining advantage over the enemy than concealment.

With the increasingly destructive power of modern weapons, however, it became obvious that display was of little use for defensive purposes. The elephant, the red coat and the massive castle became useless against the machine-gun and heavy artillery. Soldiers, somewhat reluctantly, gave up their red coats and plumes for uniforms which, because of their drabness, were more easy to conceal, and display became merely a peace-time method of upholding the prestige of governments and armies. It would be a mistake, however, to think that display has been entirely banished from warfare. As we know, the Germans have found new ways of using intimidation. Nowadays it is not done by a spectacular display of colour. The use of noise in one form or another is the most fruitful method. The terrifying noises of screaming bombs, klaxons and exhaust amplifiers were used in France to augment the shattering noise of explosions and to provoke panic among the

civil population as well as the troops, but in Oslo noise was used by the invading Germans in the opposite way. Brass bands paraded the streets and a display of strength was combined with a display of gaiety made palatable by soothing music. In both cases these methods proved successful, which suggests that an imaginative use of display is still not out of date. However, it is obvious that, particularly from the defensive point of view, concealment is now the order of the day.

To an old soldier, the idea of hiding from your enemy and the use of deception may possibly be repulsive. He may feel that it is not brave and not cricket. But that matters very little to our enemies, who are ruthlessly exploiting every means of deception at the present time to gain their spectacular victories. They can only be stopped by new methods, however revolutionary these may appear to those who believe only in ancient traditions.

Concealment

The object of concealment will be, naturally, to escape observation, but we must remember that it is important that the illusion should be complete. There is nothing more ridiculous than an unsuccessful attempt to hide. If, ostrich-like, we

merely concentrate on hiding our heads and leaving other important parts visible we shall excite the enemy's suspicion and still provide him with a target. Our concealment must be so complete that even the fact that we are hiding something shall not be apparent. Formerly the only kind of observation that was possible was observation from the ground, but since the invention of the aeroplane, concealment has become a much more serious problem. It affects not only the armies in the front line but also civilians and the vast areas in the rear which, previously, were well out of range.

Observation from the Ground

The possibilities of observation from the ground are relatively limited. A point of vantage such as a hill or a tree-top may give a wider horizon, but in any case such observation will be from a low angle and concealment is usually obtainable by taking cover behind trees or a rise in the ground. But this supposes that the enemy is only attacking from one direction, and since we now have to face the possibility of paratroops landed in the rear or rapidly-moving motorised units penetrating past our forward defences, even concealment from ground observation must be more complete. It must take into consideration

possible observation from all sides and from the rear as well as from frontal attacks.

Observation from the Air

The majority of men are unfamiliar with observation from this angle. It is therefore very important to learn all we can from a study of photographs taken from the air. The aeroplane, among many other things, is the eye of the modern army. Its invention makes camouflage more urgent, more difficult, and involves much wider areas ; it can pry into the secrets of defences and supplies which, formerly, were well hidden in the rear. Also, anything below the level of the ground could previously escape observation by scouts, but the observer from the air with his camera can see into trenches and pits without any difficulty. So that even before modern blitzkrieg tactics were used it became of great importance to conceal, by means of nets or overhead cover, trenches, guns and other defensive positions. It is clear, therefore, that from the air the use of "dead" ground and digging is insufficient for cover. From directly above there is no dead ground, and trenches, wire and tracks show up as though drawn on the map. Even a rapid glance from a fast-flying plane lays bare many secrets hidden from the ground observation (see Fig. 1).

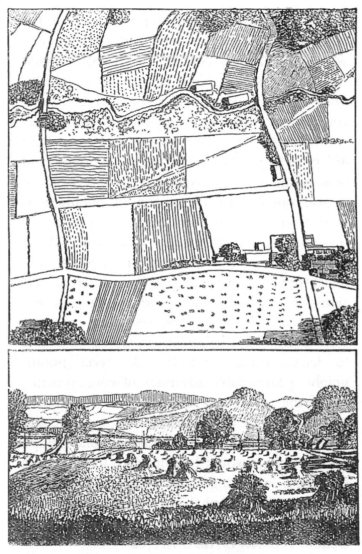

FIG. 1.—Two Views of the same Country.

But it is not only the rapid glance of the observer and his hasty notes and sketches with which we have to contend. He is also armed with cameras and films of varying sensibility. These give him permanent records which can be compared and interpreted by experts at the base. An oblique view taken at an angle of about 45° gives perspective, but the most useful and penetrating view is from directly overhead. It is also possible to take a run of photographs over a stretch of country and use any pair of these to give an exaggerated stereoscopic effect. In addition to this the use of infra-red and panchromatic films will give two different versions of the same view and supplement the deficiencies in each other, revealing in many cases things that the human eye would be unable to detect. These methods make aerial photography a formidable adversary of concealment ; but if the problem is given serious attention it will be found that it is by no means hopeless, and since it is impossible for the enemy to photograph every detail, it would be a mistake to make this an excuse for giving up the whole task ; also it must be remembered that when it comes to the point of aiming a bomb or of machine-gunning, a pilot has to rely on his own eyes.

Dangerous Symptoms

It is obviously impossible for us to remove from our country all signs of human activity. There are many things that we cannot and do not want to hide from the enemy. In consequence, we must consider what things are likely to be of interest to him. Apart from factories, dockyards and industrial plants of all sorts which may be considered nowadays to be military objectives but which are beyond the scope of this manual, the enemy observer is often on the look-out for symptoms rather than individual targets. Just as the doctor examining his patient does not worry about an individual germ but bases his diagnosis and his treatment on symptoms, so the enemy will be continually on the look-out for signs of military activity rather than individual men. These signs usually take the form of—

1. Concentrations of men and military equipment ;
2. Badly sited defensive positions ;
3. Barbed-wire defences ;
4. Spoil ;
5. Tracks.

These are the symptoms which are significant

to the enemy, whereas the ordinary common signs of human life are not ; and it is to be noted that some of these symptoms, particularly tracks and spoil, are usually more permanent than the actual movement of men.

To take an example from nature : the mole is an animal which we very rarely see, but unfortunately for him he is unable to conceal the spoil thrown up from his burrowing. His defences may be good from his enemies in the animal kingdom, but the spoil is a sure indication of his whereabouts to the mole-catcher.

How can we control these symptoms so that they are no longer dangerous to us ? The only possible answer is by an understanding of their appearance from the air and by an intelligent form of discipline by which we can control them. Discipline in itself is not enough ; it must be coupled with a consciousness of which actions are unobtrusive when viewed from the air and which are dangerous. It is in no way a mechanical discipline such as marching in step or shaving every morning. It concerns each individual in his behaviour, so that he knows instinctively how not to expose himself nor leave traces of his activities if by so doing he is betraying the operations of his comrades. This can only be done by intelligent training and an understand-

ing of what we look like from the air. And for this purpose a study of photographs taken from the air and of maps is essential for all who have not had the opportunity of flying.

Camouflage Discipline

The problem of hiding signs of military activity must be taken in hand from the start, otherwise it will often be found that tracks, spoil and badly sited positions will make the task almost impossible. Foresight will have to be used in planning the concentration or dispersal of men or equipment and the tracks that are bound to be made. For instance, supposing a convoy of lorries is to be parked in open country. It will be useless to think of track discipline after the lorries have already made heavy tracks by dispersing ; it will be necessary for a plan to be thought out beforehand so that no tracks will be made unnecessarily and those that do occur do not look suspicious. It will then be necessary to see that everybody concerned understands the scheme and does not cause it to deteriorate afterwards. Camouflage discipline cannot be applied blindly, it must be based on an appreciation of the background against which it will be seen from the air and from the ground.

Good Concealment is Good Defence

The advantages offered by good concealment from the defensive point of view may frequently outweigh the aggressive qualities of a commanding position which is too exposed. In other words, it is sometimes advisable to sacrifice to some extent a field of fire in order to take up a position which is not an obvious target for the enemy.

Of course, there may often be a choice between good concealment and a good field of fire, but in many cases it will be necessary to give priority to concealment. The battles that the Home Guard will fight will be battles fought by men against machines. Their most effective weapons are likely to be out-ranged by the guns of enemy tanks and their positions dive-bombed. Their defences, therefore, will be ineffective unless they can remain concealed until the enemy has been led into the trap and is well within range of whatever surprise there may be prepared for him. Nor must we forget the strategic value of ambushes which can allow the first wave of attack to pass over them without being noticed in order to disrupt the enemy's lines of communication and enable an attack from the rear. News from the campaign in Russia shows

us frequently the immense value of defensive tactics of this sort. By lying doggo in the forests, large bands of guerrillas and even complete armoured units have been able to place the advanced panzer divisions in a very precarious position.

Deception, Misdirection and Bluff

It would be a mistake to think that concealment is the only concern of camouflage at the present time. It may be that for defensive purposes it is perhaps the more important side, but even that would only be true if defence were purely static. Deception is the active counterpart and is of great importance in counter-attack and guerrilla warfare. To bewilder the enemy and mislead him continually as to our real positions and intentions is one of our most hopeful tasks, and to do this, ingenuity, imagination and daring are required. By using decoys and dummies we shall be able to draw the enemy's attention away from our vital points, cause him to waste his time and ammunition on false targets and by the use of camouflage and smoke screens our real positions and movements can be hidden from him. The main object of this side of camouflage will be to bring into play the all-important element of *surprise*.

CHIEF PROBLEMS OF THE
HOME GUARD

When we come to consider the rôle of the Home Guard in the defence of Britain we shall find that, particularly from the camouflage angle, it has many problems which are not necessarily the same as those that the Army has to face.

The Army has large concentrations of men, equipment and stores which it endeavours to conceal from enemy observation. They have heavy artillery, tanks and anti-aircraft batteries which need very special attention. They are also frequently on the move and are obliged to improvise their concealment in unfamiliar surroundings.

The Home Guard is not embarrassed with these difficult problems. It starts with an intimate knowledge of the ground on which it is to operate, it profits by the fact that its men are more dispersed and that the weapons that it uses are all small in size and hence easier to conceal. But its one serious disadvantage is a lack of any large-

scale issue of camouflage equipment, such as nets, paint and the more complicated camouflage materials. This, however, may be overcome to a large extent by *improvisation* and use of rubbish and natural material.

It is the purpose of this manual to make suggestions as to how this may be done ; but a word of warning must be said at the start to discourage any belief that anything suggested here is final and that it will work in all circumstances. Camouflage is always a deceptive art, and in some cases it may result in merely deceiving the man who is blindly following a few rules without understanding what he is doing or watching its effect. Bad camouflage is often worse than nothing at all, since it often results in making a position all the more suspect.

Owing to the fact that it is operating in its home country, the Home Guard in either its mobile or its static function should have every chance of preparing its camouflage in advance. Fixed positions should be well concealed before it is too late and the rush of invasion makes the work more difficult. Mobile units should train immediately with a view of getting to know every inch of cover in their districts and how to make best use of it. So that when invasion does come we shall not be wasting time searching for camou-

flage material nor be at a loss to know how to avoid offering ourselves as helpless targets. It will be well to note in advance in each district what kinds of useful material for camouflage are obtainable, both natural material, such as pine scrub and rubbish, and manufactured materials such as paint, hessian or net.

In order to simplify the problem we can take the following points as those that need our special attention.

1. *Concealment of fixed position*—machine-gun posts, weapon pits, trenches, pill-boxes, breastworks, barbed wire and road blocks.

2. *Concealment of tracks* and *spoil.*

3. *Concealment of transport* and *parking of vehicles.*

4. *Concealment of Headquarters*—approaches, surroundings and defences.

5. *Concealment of living quarters*—tents, cookhouses and latrines.

6. *Siting* of positions, tracks and wire.

7. *Creation of dummies* and *decoys.*

8. *Maintenance.*

9. *Individual camouflage*—concealment of faces and hands, helmets, rifles and equipment ; how to make sniper suits and how to use cover.

CHAPTER III

NATURE AS A GUIDE

WE have fortunately an invaluable guide in helping us to understand the principles of camouflage, in nature itself. Not only does it provide us with admirable examples of concealment, but also a study of animals and their habits will give us many ingenious ideas in the use of bluff and deception.

Concealment in Nature

There are two ways of hiding an object. It can either be placed under something that covers it completely and hides it from view, or it can be placed on top and made to resemble its background so exactly that it is almost impossible to detect. This second method is repeatedly used in nature with remarkable success. For instance, the nightjar nests on the ground in a wood, choosing a background of dry leaves and sticks with which its own colouring harmonises so exactly that it is very difficult to see. Another instance is the yellow-underwing moth which lies

C

flat on the bark of a tree, so that it eliminates its own shadow and becomes almost invisible.

This method is only successful, however, when the animal is against its natural background. The polar bear is well concealed against a background of snow and ice, but will immediately become very conspicuous in a green field. The same fact applies also to the zebra (see Fig. 2). In other words, the background against which an object is seen must dictate the kind of camouflage which is required.

In nature, concealment against the background is achieved, by—

1. *Resemblance in colour*; for example, the lion or the polar bear.

2. *Resemblance in texture.* Most creatures that live on dry land avoid bright reflections from their skins by the use of fur, feathers or rough scales. Those that live in mud or water, on the contrary retain a smooth shiny appearance.

3. *Obliterative shading.* It will be found in general that the back of any creature is darker than its belly. One of the best examples to quote is the mackerel, which attains a remarkable degree of concealment by this means, its back being very dark and its belly very light. The reason for this is easy to understand, since it is the back of an animal that is most exposed to the light,

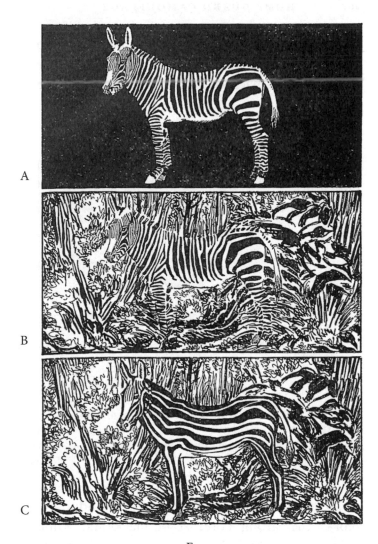

FIG. 2.

A. The zebra against the wrong background is very conspicuous.
B. Against its native background it is well hidden.
C. The disruptive pattern would not be effective if designed to outline the form.

while his belly is in shadow ; it will be possible to counteract the natural effect of light and shade by keeping its back dark and its belly light (see Fig. 3).

4. *Disruptive patterns.* The most striking ex-

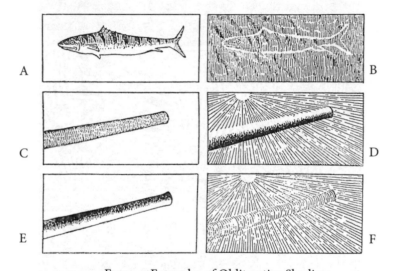

A.

B.

C.

D.

E.

F.

FIG. 3.—Examples of Obliterative Shading.

A. Mackerel, wrong lighting. B. Lighting from above.
C and D. Gun-barrel uniformly painted makes heavy shadow underneath.
E and F. Gun-barrel painted dark on top and light underneath obliterates shadow.

ample of a disruptive pattern is to be found in the zebra. The strong contrast of black and white stripes with which it is covered would appear to make it highly conspicuous (see Fig. 2). Actually these markings, in its natural back-

ground, succeed in giving the zebra an extraordinary degree of concealment. It should be noticed that the stripes are designed in such a way that they do not outline its form but, on the contrary, cut across the outline, across the body and across the legs. In this way it is bounded by a broken line, instead of a continuous outline (see Fig. 2).

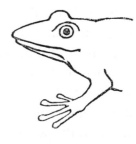 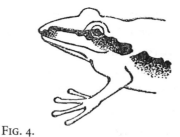

FIG. 4.

Frog without Concealment Frog with Eye concealed
of the Eye. by Dark Streak.

5. *Concealment of small vital points.* The eye is a small dark vital point which makes an easy target if nothing is done to conceal it. Many creatures manage to obtain this concealment by a dark streak across the face which covers the eye and renders it much less conspicuous (see Fig. 4).

6. *Elimination of cast Shadows.* Many animals appear to be highly conscious of the fact that they may be easily betrayed by their shadows.

The easiest ways by which they overcome this difficulty are either by sheltering in a patch of shadow which conceals them and obliterates their own shadow or by taking up an attitude, such as the moth lying flat on the bark of a tree or the lizard crouching on a wall, which covers their shadow completely.

7. *Immobility*. It is well known that movement inevitably attracts the attention of the observer. Animals often escape notice completely until they are seen to move. This is well understood in nature. Many creatures will remain immobile in front of an advancing enemy and refuse to bolt until the very last moment. The fact is that movement is extremely difficult to hide. Prob-ably some form of smoke screen is the only possible method. Of this we also find an example in nature; the octopus, which escapes from its enemies by emitting a smoke screen of sepia.

8. *Behaviour*. In nature we frequently find an instinctive understanding of the most advan-tageous way to use cover. The nightjar knows the right surroundings to choose for its nest; it will never be found nesting in a green field. Each creature behaves so as to gain the greatest advantage from its surroundings. The bittern for instance, when taken by surprise on its nest, sits bolt upright, holding its beak erect in the air

the reason being that it nests among reeds which form a vertical background and by so doing it attains a remarkable degree of concealment.

Deception in Nature

We shall find in nature that the methods of deception that are used are as remarkable as those of concealment. There are many ways in which animals manage to mislead their enemies both for defensive and aggressive purposes. And there is a great deal to be learned from a close study of their behaviour. Some of the most instructive methods are :

1. *Deceptive markings.* Prominent markings in the shape of an eye, the purpose of which appears to be to draw away the attention of an attacking enemy from the most vital part, the head, are frequently found. There are many species of butterfly with eye spots near the edges of their wings and it is not infrequent to find the marks of a bird's beak on this eye spot, the butterfly other- wise having escaped uninjured (see Fig. 5).

2. *Deceptive behaviour.* Decoy movements and noises are frequently used by birds to draw away the enemy from their nests. Another example of decoy movement is the lizard who, when attacked by a bird, detaches his tail and leaves it wriggling behind him while he takes up a new position

and remains motionless. The bird is inevitably attracted by the movement of the tail and devours it, whilst the lizard escapes further attention.

3. *Mimicry*. Many creatures attain a high

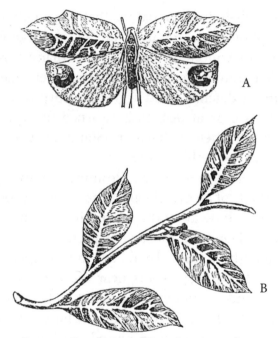

FIG. 5.—Grasshopper (Tanusia corrupta).

A. In flight. B. Perched as a leaf.

degree of security by imitation of some uninteresting or undesirable object in their surroundings.

There are caterpillars that can resemble a growing twig and spiders who make a web on

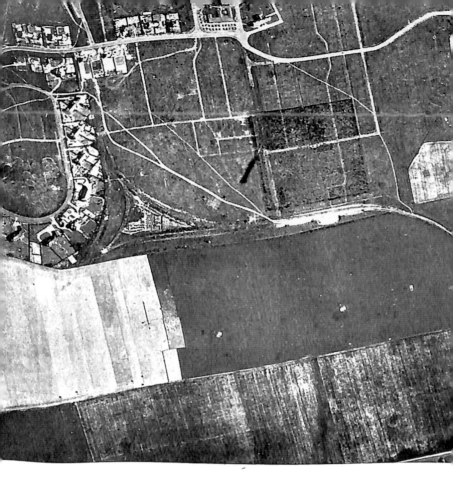

PLATE 1. Height 3,000 ft.

Vertical view of cultivated country in summer, showing contrasts in texture. Notice the clover field stretching across the middle of the photograph and the sheep pens dividing the part that has been grazed from the long cover, also the tracks across the grass and the circles on the grass plot among the houses where horses have been exercised and the rough texture of the grass destroyed.

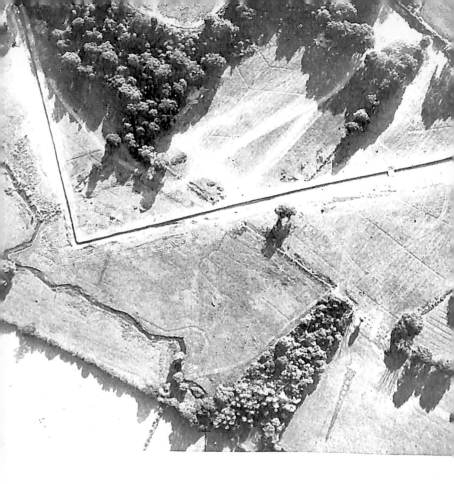

PLATE 2 (*see* page 48). Height 1,500 ft.

Portion of an anti-tank ditch, showing tracks spoil and interference with the natural pattern of the country. Notice the heavy shadows cast by trees in full leaf and the conspicuous shadows cast by pylons.

a leaf to resemble exactly a bird's dropping. The latter, incidentally, by its cunning escapes attack from the birds and at the same time allures its prey of small flies by the same device. The grasshopper seen in Figure 5 combines deceptive eye markings on its wings when it is flying with a realistic imitation of a leaf when it is at rest. Its behaviour in perching so as to simulate the natural position of a leaf and the way in which the irregularity of the upper edge of the wing makes it look as though it had been partly eaten away emphasise the extraordinary degree of cunning and the accuracy of detail which is found necessary by these insects in their fight for life.

APPLICATION OF LESSONS LEARNED FROM NATURE

Importance of the Background

ALL concealment, as we have seen, in nature depends in the first place on a consideration of the background against which a man or an object is likely to be seen. From the ground view, the background will consist of walls, trees, hedges, etc., but from the air the background has a very different appearance. Like a map, it will be the plan or pattern of the immediate surroundings. It will consist of roofs, fields, roads, rivers, etc., and will be on a wide scale. The general tendency will be that the contours which appear important from the ground will tend to disappear (see Fig. 1).

For a scout or a mobile object such as a vehicle the background naturally will vary, and camouflage will have to be adaptable to the change of surroundings. Also seasonable changes in the background must not be forgotten.

Importance of Texture

In order to obtain concealment, it would appear at first sight that resemblance in colour is the most important factor. Actually, this is not the case. The fact is that a smooth surface reflects more light than a rough surface. In consequence, supposing we have a smooth board and a rough piece of bath towel, both painted with exactly the same colour, the smooth board will inevitably look lighter in tone. Light, like a ball, bounces more easily off a smooth than a rough surface and, consequently, smooth texture will appear lighter than rough texture regardless of colour. It is easy to verify this by looking down from a height on a patch of newly mown grass. From the ground frequently this patch will appear darker in colour than the long grass around it, but from the air, owing to its smoother texture, it will appear inevitably lighter in tone.

The photograph reproduced in Plate 1 shows a stretch of English country in summer. Near the centre a strip of clover runs right across the photograph, but the left-hand side of this strip appears very light in tone whereas the rest of the field is much darker. This is due to the fact that the left-hand end had been grazed by sheep. They can be seen in pens along the dividing line

between the light and the dark parts of the field. In spite of the field looking almost uniformly green from the ground, from the air this striking contrast in texture becomes apparent between the smooth part which has been grazed and the rough part which is still long clover and where each leaf casts its shadow. It is easy to imagine, in consequence, that if a pill-box with a smooth concrete roof were placed among the long clover it could not be concealed by the use of colour alone, even supposing that a skilful realistic reproduction of clover leaves had been painted all over it. The smoothness of the texture would cause the roof to reflect light and the painting would be useless. It is also interesting to notice how the paths across the grass in this photograph appear light in tone since the texture and its contained shadow has been trodden down and destroyed.

It is, therefore, essential to match with the background in texture as well as in colour and not rely on a coat of paint alone. This fact is made all the more important since observation from the air is based on the use of the camera which eliminates colour and accentuates differences in tone. It will apply therefore mostly to roofs such as roofs of pill-boxes or vehicles and upper surfaces such as steel helmets, etc.

Colour

While bearing in mind the importance of texture, particularly for close observation we must not forget the rôle played by colour. The most useful colours will be found to be dull earth colours, yellowish or brownish greens, neutral greys, brick reds and black.

Earth and Brick colours will be determined by the prevalent shades in the local surroundings.

Green is the colour which is likely to present most difficulty. It is very easy to err on the side of mixing a green with too much blue. The majority of green paints and dyes suffer from this drawback when used in camouflage. There is very little blue-green in nature ; also, when a green paint contains too much blue there is every probability that in time the yellow in it will fade and the resulting colour appear even more blue, owing to the persistence of the prussian blue that is frequently used in green paint. Also, blue is the colour in the spectrum which reflects most light. A green which starts by being too blue will, from the air, appear all the more false and out of tone as time goes by. Hence it is very important that light green should be kept yellowish in appearance and dark green have a good proportion of brown. The same difficulty is

likely to occur with *grey*. The dark greys in consequence should be of a neutral shade and light grey verging on the yellowish colour of cement.

Black is essential for strong contrasts, such as those which we may require for disruptive patterns, or for imitating real shadow. It should be of a good mat quality and as intense as possible.

Mat paint. All these colours should combine as far as possible a rough texture so as to avoid reflections. They are supplied in the form of mat camouflage paint by most of the paint manufacturers in the country. And in spite of the drawbacks caused by the dominating importance of texture, they are undoubtedly of great use. Gritty paint can give slight texture to a smooth surface but, usually, it is preferable to obtain a rough texture before painting.

Disruptive Patterns

In the early days of the war it was thought by many people that camouflage was simply a question of painting stripes over an object. It was supposed that these stripes, known as disruptive patterns, were going to make the object invisible. It is not difficult to see how hopelessly

unsuccessful this method was when applied in this haphazard way. In fact, it frequently resulted in making the object all the more conspicuous and stamping it with a suspicious appearance. There are cases, however, as we have already seen with the zebra, in which they can be used to advantage. A pill-box situated against an irregular background of trees might be treated successfully in this way, and disruption will be found to be particularly useful when applied to snipers' suits and small articles of equipment. Owing to the broken outline and the variety of tones, it is almost certain that part of the pattern will match up exactly with the tone against which it is seen and disruption of the characteristic shape of the object that it covers will occur (see Fig. 6).

Designs of this sort can be combined with *obliterative shading*, i.e. the top surfaces should in general be kept darker and more textured than the under or shaded surfaces and the use of patches or streaks of black to cover small vital points such as loop-holes may be found effective (see Fig. 25).

In this connection if the object to be painted is a gun-barrel such as that of the Northover projector which does not have a high elevation and hence keeps its under side always in shadow,

Possible background

Wrong background

FIG. 6.—Disruptive Patterns applied to a Pill-box.

the principle of obliterative shading may be used to great advantage, by painting the under side of the barrel white and shading off to a much darker tone on top (see Fig. 3).

Concealment of cast Shadows

From the air a shadow cast on the ground is often more visible than the object by which it is cast. This is particularly true from directly overhead — the angle most favourable for aerial photography. From this view a man standing on the ground is nearly always smaller in dimension than his shadow at any time of day, but specially when the sun is low. It is not only in bright sunlight in the summer that this occurs. On a clear day in winter, when the sun never reaches a very high angle and when the overhead cover of trees in leaf is lacking, cast shadows are likely to be very conspicuous. Men must therefore be trained to be conscious of their shadows. Just as certain moths and lizards manage to eliminate their shadows by lying flat on a tree trunk or wall, so it is often possible for a man to lie flat on the ground or hide in the protecting shadow of a wall or a tree in full leaf. To use the shadows of trees or houses for concealment in this way is obviously good. It will also help to hide

movement. But it is important to make sure that the shadow is sufficiently dense, i.e. the shadow cast by certain trees with thin foliage such as the birch or a leafless tree is usually quite insufficient.

Concealment of cast Shadows from Vehicles and large Objects

It is worth remembering that a shadow cast by an object on a rough surface reveals the silhouette of the object less clearly and makes less contrast than when it falls on a smooth surface. Therefore, in open places where overhead cover is lacking it is often preferable to park a vehicle on the sunny side of an object such as a hedge, a ditch or a patch of brambles rather than in a patch of shadow which is not big enough to cover the roof of the vehicle. This also applies to a car that is parked close up to the sunny side of a wall. In this case when seen from the air the shadow will be scarcely visible, it will be sandwiched in between the car and the wall (see Fig. 7).

All such solutions naturally are only temporary, they depend entirely on the angle of the sun and a constant watch must be kept to see that a change of lighting does not reverse the effect.

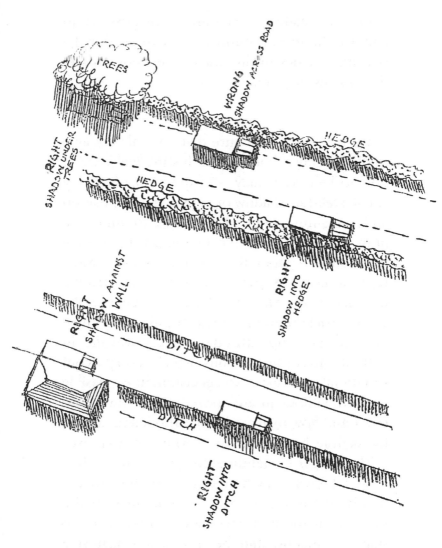

FIG. 7.—Methods of parking Vehicles so as to conceal cast Shadows.

In dry weather it is sometimes possible to confuse the regular outline of a cast shadow by burning patches in the grass on all sides where the shadow may fall.

Behaviour

We have seen in nature that animals are able to obtain concealment by an instinctive sense of how to behave. It may be a question of getting rid of a tell-tale shadow or of taking up a position and remaining motionless, so as to imitate a branch or a leaf or it may be the acting of some farce, so as to draw the enemy's attention away from a nest. In particular the most striking instance is the way in which they choose the correct background for their disguise and know how to take up attitudes which will fit in with it. These are lessons which every scout should take to heart. No concealment is possible for him without an understanding of how to use cover and how to avoid being silhouetted against the skyline, how to move and when not to move.

The danger of standing up against the skyline is well known, but it is often forgotten that it may be just as serious to stand out in the sunlight, in front of the dark shadows of a wood or to stand in shadow and be silhouetted against a patch of light beyond. In fact it is when a man

is out of *tone* with his background that he becomes conspicuous. It is easy to watch a man as he moves about in the light in front of a doorway, but as soon as he steps back into the shadow of the doorway itself he becomes much less conspicuous. This means that we are able to control the tone of light and shade which we present to the observer, provided that we are able to become conscious of our own appearance in whatever position we may happen to be (see Fig. 8).

But, unfortunately, it is impossible for a man to see himself from a distance. Training which is intended to teach a man how to control his tone, i.e. the contrast of light and shade between him and his background, will consist chiefly in getting men to watch each other and criticise each other's behaviour. A man must be told immediately when he is making a conspicuous target of himself and the reason for it explained. Naturally, this task would be much more difficult if uniforms were very light or very dark in tone i.e. white or black. Khaki battledress is designed so as to start with a neutral tone, which means that its wearer is more able to adjust himself readily to his background. This adjustment may merely mean one pace forward or backward in order to merge into the tone of his surroundings.

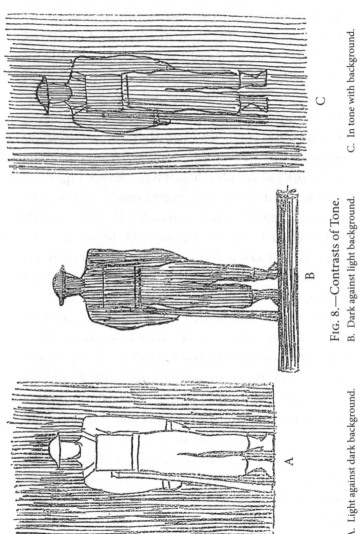

Fig. 8.—Contrasts of Tone.

A. Light against dark background.

B. Dark against light background.

C. In tone with background.

It is often thought that to be silhouetted against the skyline only occurs when a man stands on the crest of a hill and is seen against the clouds and we forget that in this country mist and fog can often obliterate a background which would otherwise appear to be sufficiently close. Actually, backgrounds are more reliable on a clear sunny day than they are when there is mist. The only possible rule to give is for a man to keep as close as possible to whatever cover there may be, whether it is a hedge, a tree trunk or a gate post. If a man stands beside a tree trunk with a patch of lighted ground or mist behind him, he will be very easily seen. Whereas, if he stands with his back to it, close against it, this behaviour will make him much less visible (see Fig. 9). Hiding in this way, in front of cover, but close to it, so as to unite with its form and shadow has the advantage that it offers an unobstructed view for observation and a better field of fire.

The question of behaviour, however, does not only apply to individuals, it also applies to groups of men, their tracks and traces. It is possible when dispersing men to conceal them from air attack by fitting them in rapidly with whatever natural features may be at hand. Supposing there is a hole in the ground, it may be possible by getting men to lie side by side on the ground

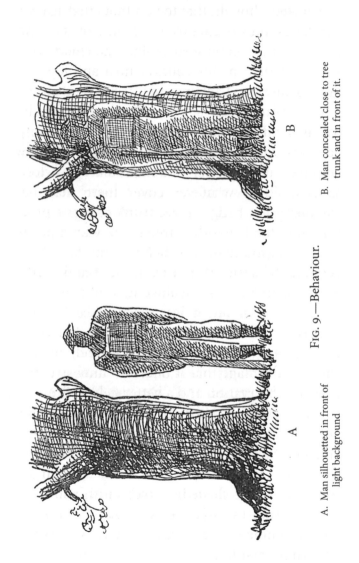

A. Man silhouetted in front of light background

B. Man concealed close to tree trunk and in front of it.

FIG. 9.—Behaviour.

to continue this dark patch so that from the air they will merely appear to be part of it. Five or six men crouching together, if they can hide their helmets, can look like a small bush. Small groups dispersed in this way in rough country, where there is no overhead cover, by rapidly forming patterns similar to those on the ground, can obtain better concealment than if they are all scattered in the open. The question to weigh up is whether complete dispersal is better than the deception that this may afford. In the same way the shadow of a tree can sometimes be extended without attracting attention, if its shape is imitated, supposing in this case that the shadow itself does not give sufficient cover.

From the air it is often possible to detect defensive positions, however well they may be concealed, by the tracks leading to them, by the spoil and by signs of human life, such as cook-house and latrines. However, the behaviour of men can be controlled so that these suspicious symptoms of military activity are no longer conspicuous, by organisation and discipline, provided, of course, that the reasons for discipline and the methods to be followed are well understood and applied from the start. This cannot be done by rule of thumb ; each particular case will dictate its own necessities.

The natural and healthy tendency to seek, in the first place, cover from fire must always be combined with the knowledge of how to take cover from observation from the air and from the rear. The enemy, in this war, is armed with powerful aids to the human eye, such as field glasses and cameras. We must develop a consciousness that we can be seen from great distances and from any angle. But the behaviour of a sentry or a scouting patrol, who are to observe while remaining unobserved, will be dictated primarily by the necessity for concealment. Remember, that one badly concealed sentry may be enough to betray the whereabouts of his companions, and that the conspicuous behaviour of one man can cause the annihilation of the whole of his unit.

Constant training and the use of our eyes so as to see and analyse things clearly are the only ways to master these difficulties. The rapidly changing light, and the difference in the appearance of things on a wet day and in sunlight, need careful study. For instance, shiny surfaces such as waterproof capes are less visible on a wet day, the reason being that the rain makes most surfaces shine. In consequence as the cape offers a light appearance it is likely to be very conspicuous against the dark background of a hedge.

CHAPTER V

SITING AND CAMOUFLAGE DISCIPLINE

Pattern

IN discussing the question of backgrounds as
seen by an observer from the air, we noticed that
these backgrounds resemble the patterns with
which we are familiar from looking at maps and
aerial photographs. Each district seen from the
air has its own individual pattern made up of
mountains, roads, rivers, railways and varying
types of vegetation. The pattern of mountainous
country with its irregular curving valleys will be
very different from the pattern of flat country
which consists much more of straight lines and
geometrical shapes. The pattern of the normal
English landscape is one of irregular fields, wind-
ing roads and rivers, clusters of villages and
woods. Again, the pattern of a town will be
very different, with its geometrical shapes of
streets and houses (see Fig. 10).

These are the backgrounds against which our
behaviour can be watched from the air. They
lie spread out below, and the greater the altitude

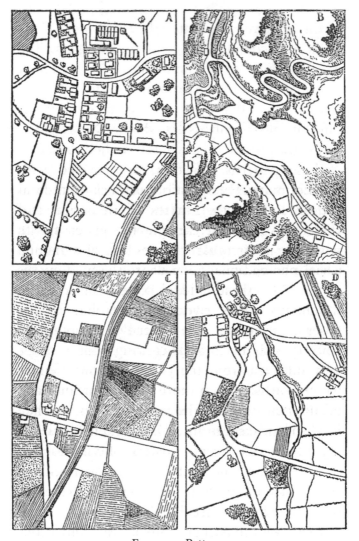

FIG. 10.—Pattern.

A. Suburban area. B. Mountainous country.
C. Flat country. D. Typical English rural country.

of the observer the flatter they will look. Contours and colours will tend to disappear. The masts of ships, pylons and chimneys which look formidable landmarks from the ground will be so foreshortened that they will become quite insignificant. It is only their shadows, stretching across the ground, that will reveal their presence.

These patterns, however, are covered with signs of human life. Roads, railways, canals and hedges, link up the centres of life, towns and villages. Agriculture straightens out as far as possible the irregular shapes of wild nature. Chalk pits and quarries eat into the bold curves of the hills. These are the normal signs of life which can be seen and photographed by the observer from the air, but they are not really what the enemy is looking for. Military activities and defensive systems have their own characteristics which do not usually coincide with unsuspicious signs of normal life. It is this fact that will be likely to furnish the enemy with the clues he needs. By photography he can obtain detailed records not only of the pattern as it is at any given time but also he can make comparisons with photographs taken earlier and watch any changes which may reveal suspicious activities. Anything that interferes with the natural pattern and appears to have a military motive

will interest him and any of the characteristic shapes, such as Nissen huts, tents, slit trenches, road blocks, circles of barbed wire, roofs of pill-boxes and an injudicious use of disruptive camouflage patterns which inevitably suggest military activity, will be noted and interpreted, so that little by little he will be able to obtain detailed knowledge of all that we had intended to hide.

We must therefore understand how to make our military symptoms fit in with the normal pattern. There is a simple parlour game which may help to give us a grasp of how to hide objects by fitting them into a familiar background. A few common objects are selected, such as a knife, a hat, a red book and a bottle. One side then hides the objects so that they are still in full view but placed so that their colours and particularly their shapes make them appear to be part of the furniture of the room in which they have been placed. The knife may be placed along a silver picture-frame, the hat on top of a lampshade, the red book to fit in with the corner of a red tablecloth and the bottle between the pedals of the grand piano. If this is well done the other side which has to find the objects when returning into the room will be duly baffled. This simple game seems to illustrate how objects can be incorporated into surroundings in which

they do not belong so long as the original pattern is followed closely (see Fig. 11).

If, therefore, we wish to conceal military activities, we must endeavour to site defensive positions, tracks, wire, car parks, cables, etc., in such a way that they do not violate the natural pattern. Good siting will greatly facilitate this.

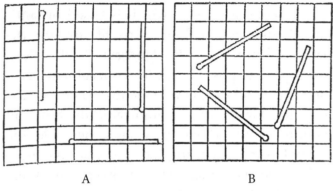

A B

FIG. 11.—Pattern.

A. Matches fitted into the pattern. B. Matches cutting across the pattern.

The symptoms that we wish to hide will coincide with the normal pattern of life and appear unsuspicious. Whereas, bad siting and lack of discipline which does not take into consideration these necessities will make concealment difficult, costly and often impossible.

Tracks and wire which form fresh lines across the ground must be made as far as possible to

fit in with the existing lines in the landscape. If, however, this cannot be done they should still be made to harmonise with the surrounding pattern made by agriculture or natural features. A circle of wire around a position will make a bull's-eye target for the enemy, whereas a rectangular enclosure will look like a small field (see Fig. 12).

A scheme of defence which is based on anti-tank islands planned so as to fit in with the natural features of the landscape will afford much greater possibilities for concealment than long lines of defensive systems, such as the Maginot Line with its anti-tank ditches and dragon's teeth which, inevitably, override the normal pattern, cutting like scars across fields and hedges (see Plate 2). For these scars there is no possible cure. Not only do they violate the pattern but the great quantity of spoil thrown up on either side makes concealment impossible. It is true that in time vegetation may be induced to cover them but even then, mounds and shadows will make them easy to detect by photography. The whole plan of the defensive system with its strong points clearly marked will be seen at a glance from the air and the attacking force will be able to calculate with accuracy the exact spot where a sledgehammer blow will be most

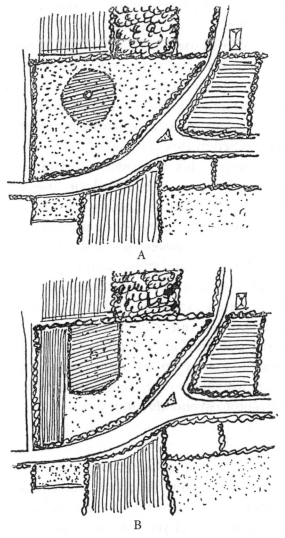

FIG. 12.—Siting of Wire round a Position.
A. Bad. B. Good.

effective, that is, supposing he limits himself to frontal attack. His task will be all the more simplified if he decides on a simultaneous airborne attack in the rear ; since his knowledge of the strong points obtained from air observation will enable him to avoid opposition when landing his paratroops, while these strong points are kept well occupied by dive bombers.

If, however, this question of pattern is well understood, concealment will be the natural result. If the existing lines of the landscape, formed either by nature or the normal activities of man, can be followed in siting trenches, wire, anti-tank ditches and mines and in planning the parking of vehicles and tracks, then camouflage will not be an expensive and complicated form of magic which can only be achieved by trained experts, but the logical outcome of an understanding of how to fit into the background against which we are being observed. *Good siting is 90% of concealment.*

Tracks

A track is one of the symptoms of activity which is most likely to betray our positions to the enemy. It is possible to conceal a strong point perfectly and yet give away its exact position by a track leading up to it.

A photograph taken at the end of the last war demonstrates this point very clearly (see Plate 3). In late October 1918, the Germans had recently taken up new positions in a wood, seen at the top of the photograph. They had taken great pains to give their positions really thorough concealment. All spoil had been removed and no trenches or other fortifications could be detected from the air. It is possible to notice a few felled trees in the photograph but otherwise their concealment from this point of view was entirely successful. On examination of the photograph we find, however, two suspicious symptoms. (1) In the fields in front of the wood two small parallel tracks may be seen winding across the meadows. These tracks were made by the parties sent out to put down fresh wire, though the wire itself having just been laid is not visible. (2) In the wood very serious tracks are to be seen leading up to five points along the road. These two symptoms were sufficient to cause suspicion about this otherwise innocent piece of wood and when prisoners were captured from this sector complete information was obtained about the enemy's activities. From them it was learned that five companies of Germans were occupying the wood and that under cover of darkness food kitchens were being

brought up to feed them at the five points of concentration along the road. To complete this the exact time of arrival of the food kitchens was also discovered. As a result heavy shelling by our artillery caused the Germans to lose the best part of a battalion. This story is a severe warning against negligence in track discipline. It is possible that the Germans miscalculated, thinking that the overhead cover afforded by the trees would be sufficient to hide their tracks, but in late October the foliage was obviously insufficient and even in summer it is often unwise to rely on tracks in a wood being invisible from the air.

We must therefore see to it by planning and discipline that our tracks do not become suspicious. The most tell-tale types of tracks are shown in Figs. 13, 14 and 15.

Methods for Concealment of Tracks

A general rule is to follow existing lines, such as hedges, ditches, walls, furrows, or the dividing line between two crops. One narrow track is less visible than widespread tracks and betrays less activity.

Tracks leading to a strong point in the open should not stop short at the position, thus indicating the whereabouts like an arrow pointing at it. They

Suspicious tracks.

Fig. 13. A track leading out
into the open and stopping at
a vital spot, whether this spot
has been camouflaged or not.

FIG. 13.

Fig. 14. Tracks radiating out
from a point of concentration.

FIG. 14.

Fig. 15. Tracks which have
been dispersed in a vain
attempt to hide them.

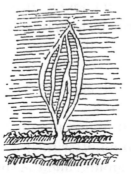

FIG. 15.

can often be continued by a false track so as to link up with some natural feature such as a road, a wood or a house (see Fig. 16).

False tracks require maintenance in order to keep them alive. Sometimes they can be made with gravel, cinders, lime, spoil from diggings, or a furrow cut across grass land. If they are to be taken across plough they should cut across the furrows and not follow them in order to be apparent. It must not be forgotten that a dummy position also needs a false track.

Bad tracks that have got out of hand owing to lack of discipline can sometimes be obliterated by ploughing and a new track can be taken along a furrow.

Tracks in woods will only be concealed when foliage is thick, and even then they can sometimes be seen like a dotted line through the gaps in the trees. In winter they will be clearly visible. In consequence, planning and discipline must not be forgotten even in a wood.

Spoil

Spoil is again a symptom which is of great value to the enemy and great care must be taken if information is not going to be given to him unnecessarily. If a hole or a trench is dug in the ground and the spoil is carefully removed

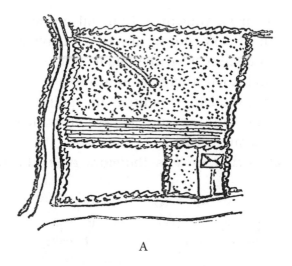

A

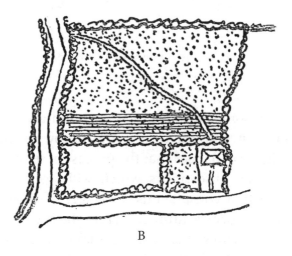

B

FIG. 16.—Track leading to a Position in the Open.

A. Wrong. B. Right (continued across field by false track).

by carrying it away in sacks it will appear merely as a small dark spot or line which is often difficult to discern from the air. If on the contrary the spoil is left it will act as a frame around the trench. Especially in grass land, spoil shows up very light in tone and makes the trench very conspicuous (see Fig. 17).

Removal of spoil is therefore often the best

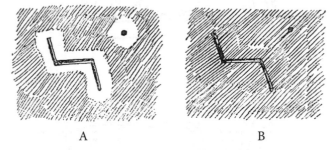

A B

FIG. 17.—Trench and Bombing Pit (seen from above).

A. Surrounded by spoil.
B. With spoil removed.

plan. In some cases if it is dumped at a suitable distance it may act as a useful decoy position. But there is a danger that the process of removing spoil may cause tracks which will again make the position conspicuous. One way of avoiding this is to form a human chain which can pass the spoil along the line in sacks or buckets, otherwise, track discipline must be organised from the start.

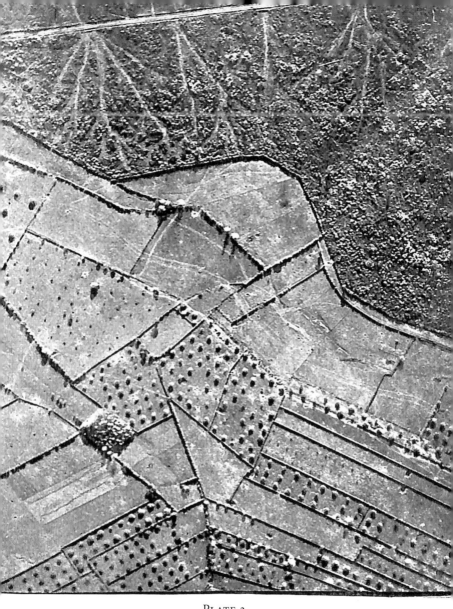

PLATE 3.

Camouflaged German positions in France, Oct. 1918. Notice the symptoms of their activities—Tracks in the wood and tracks of wiring parties across the meadows.

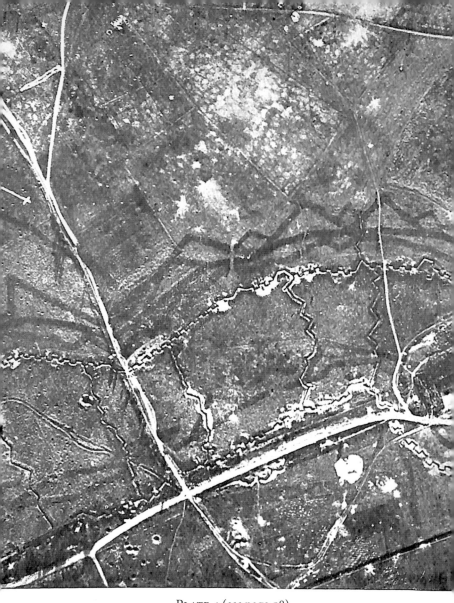

PLATE 4 (*see* page 58).

Front-line trenches and barbed wire in Northern France, Sept. 1918. No attempt to conceal trenches, wire or spoil from air attack had been made.

From the experience of recent campaigns it is being found that trenches dug rapidly with spoil left around them give dive bombers an easy target. In consequence, in many cases it may be preferable to sacrifice the protection of parapet and parados keeping a clean knife-edge to the trench and rely instead on the better concealment which this will offer.

Covering of spoil which cannot be removed or is retained for additional protection against fire can be done with turf, dyed hessian or garnished nets. When turf is used care must be taken to remove all the turf and top soil from the site before starting to dig. The turf should be stacked, turf to turf and earth to earth with a layer of top soil between the layers of earth. Otherwise, the turf will die in a very short time in hot weather (see Fig. 27).

Bad Scars. The significance of spoil that has got out of hand and become a scar that is impossible to conceal can sometimes be hidden by continuing the scar on all sides. This method is particularly useful on chalk soil where the slightest scratch in the grass shows up very clearly. By enlarging the scar in this way the enemy is unable to decide at which point a real position has been sited.

Wire

When barbed wire has been newly laid the wire itself is not visible from the air nor does it cast a shadow that can be seen. Its presence, however, may be given away by the tracks of the wiring party on either side. These will be less obvious usually when concertina wire is used. However, wire that has been in place for only a few weeks in summer begins to show up very clearly, because the vegetation grows up more rapidly sheltered underneath it and the texture becomes heavier and darker. The same thing can be seen in photographs taken from the air of the front line in the last war. No attempt had been made to conceal the wire or the trenches, which show up clearly outlined by spoil and sandbags, from the air (see Plate 4). Wire that has been placed round a position may draw attention to it by forming a dark circle around it and interfering with the agriculture and the natural growth of the crops (see Fig. 18). Hence it is obvious that to avoid this the siting of wire should be planned so as to fit in with the natural pattern. Whenever possible it should be placed along hedges, ditches, roadways or walls and when it is necessary to lay it out in the open it should be made to harmonise with the existing

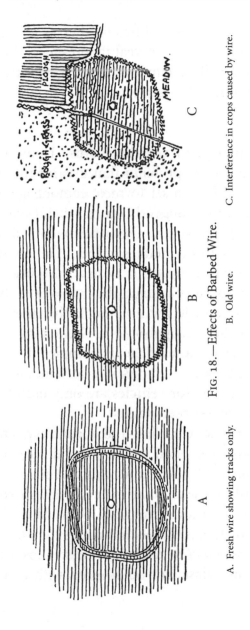

FIG. 18.—Effects of Barbed Wire.

A. Fresh wire showing tracks only.

B. Old wire.

C. Interference in crops caused by wire.

lines of the surroundings so that as changes in vegetation begin to reveal its presence, the lines it makes will resemble a small enclosure or a field among fields (see Fig. 12).

Vehicles

Camouflage of vehicles for the Home Guard is not the same problem that it is for the Army. The Army have a set form of camouflage for all vehicles which depends on mat paint and nets. The mat paint is certainly useful in that it deadens reflections from metal surfaces. The disruptive patterns which up till now have also been used are not so satisfactory. They do certainly not make the vehicle invisible but rather they make it inevitably recognisable as belonging to the Army. Their camouflage is completed by nets. As we know it is impossible to conceal movement and nets for vehicles are only useful when the vehicle has been parked.

The Home Guard, on the contrary, employ all kinds of civilian transport and have not at their disposal the same equipment. It would obviously be a mistake to copy the disruptive patterns of the Army and think that this is sufficient. Other methods must be found.

Suppression of Reflecting Surfaces. Glossy paint, nickel and glass can be covered with a coat of

mat paint which should be of a neutral shade, if possible darker on the roof than on the sides and under-surfaces. If mat paint is not procurable a temporary solution which may be useful is to cover the vehicle with oil or grease and throw dust over it which will stick and give it a temporary mat surface.

Nets. Vehicles when they are stationary can be successfully hidden by large nets, provided that the net is hung over the vehicle as a curtain to prevent observation and not draped close to it so as to reveal the shape underneath. They may be hung from a tree or held away from the roof by branches placed under the net and should be pegged to the ground, well away from the side. In this way the net will cast a pattern of shadow over the vehicle and its shape will be well hidden.

Parking. To conceal cars when they are parked we must deal both with the question of shadows and the pattern into which they are to fit when seen from the air. Shadows have been discussed above and the problem of pattern is the same in principle as it was for defences and tracks. Whenever a regular background of walls or hedges is found, the vehicles can be lined up close to them, but in open wild country an irregular dispersal, fitting in with whatever

patches of rough ground or vegetation there
may be, will be found to be more successful,
although in this case care must be taken to

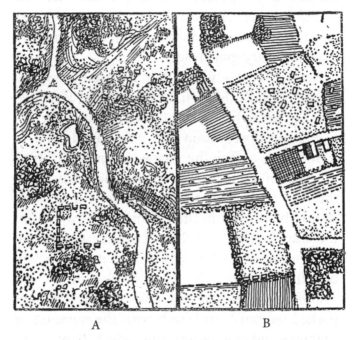

A B

FIG. 19.—Parking of Vehicles.

A. Irregular surroundings need irregular dispersal—not regular lines.
B. Regular pattern of hedges or streets needs regular lines—not irregular dispersal.

avoid betraying the vehicles by their tracks.
This can best be done by sending forward a
scout to organise the dispersal from the start
(see Fig. 19).

From ground observation the wheels and the shadow underneath the vehicle should be concealed. This can be done with sacks or brushwood. The shadow at the back of the

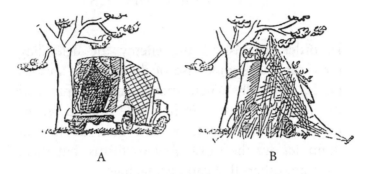

A B

FIG. 20.—Concealment of a Vehicle with M.T. net.

A. Wrong. B. Right.

interior of a lorry should be hidden by keeping the curtains closed or covering the opening with a net. If nets are lacking, branches and scrub can be used on the roof (see Fig. 20).

Chapter VI

DUMMIES AND DECOYS

In order to mislead the enemy the defending force can make good use of dummies of various kinds, especially when movement is rapid and the advancing force has had little time to reconnoitre. Dummy positions and guns or human dummies are the most obvious forms, but there are many others that can be imagined.

Dummy Positions

Dummy positions can in some cases be made from positions that have been put up as part of a former defensive scheme and since abandoned, preferably because of their conspicuousness. But such positions to be effective as dummies must still be given an appearance of being manned, otherwise they are not likely to interest the enemy. They may be camouflaged badly with clumsy, disruptive painting which will make them look all the more suspicious. The necessary signs of activity such as tracks and spoil should be kept alive. The positions must not be

allowed to appear derelict, though precautions may have to be taken to avoid letting them fall into the hands of the enemy and offering him protection. In this way at road blocks or strategic points, where the enemy is bound to expect resistance, a false target will be provided for him, on which he may waste his time and ammunition.

Dummy Guns and Gun pits

Dummy guns and gun pits improvised with whatever material can be found should also be given the necessary tracks and signs of life, possibly imitation gun flashes can be used. At night a rifle flash can be imitated even with a flashlight.

Human Dummies

Human dummies can be used as in the last war from a trench or from behind a wall or hedge. In order to do this, a head and shoulders with helmet can be set up on a stick and held close to the body by a man concealed below. It can then be walked slowly up and down behind the wall. The more firmly it is held the better will the movement of a man walking be imitated. Care must be taken, however, to give the dummy a movement which appears authentic. This remark also applies to a dummy made of a

F

stuffed sack that can be dragged across the ground on a long rope. Its movement also must appear to be the authentic movement of a man creeping slowly across the ground, otherwise the enemy is unlikely to be deceived.

Decoys

There are innumerable kinds of decoys that can be improvised. All sorts of material can be used ingeniously to attract and mislead the enemy. A simple device such as placing, concealed in a bush, bits of tin and mirror which will flash as they are moved by the wind or by a string pulling them can give a suspicious appearance and draw attention away from more important movement. At night the flashing of lights or bonfires can cause confusion.

Sandbags, being in themselves so characteristic of military activity, can often be used as a decoy position especially when placed on a window sill or the parapet of roof in street fighting.

Booby Traps

Booby traps might also be considered to enter into the sphere of camouflage. They are certainly a method of bewildering and disconcerting the enemy, but their construction must be left to those who are experts in dealing with explosives.

CHAPTER VII

FIXED POSITIONS

Pill-boxes

IT is impossible to give rigid copybook proposals for the camouflage of pill-boxes. Each case must be studied on its own merits. It must be viewed from all possible angles of approach, as well as from the air, from the distance at which it is most likely to enter first into view for the advancing enemy and also from close quarters.

In cases where concealment is possible the following methods may be of use.

Roof surfaces must be made to match up with the ground around in texture. It has been pointed out above that it is of little use to rely on paint alone. Among natural surroundings a variety of texture may be used to disrupt the regular shape of a flat top, care being taken to hide any conspicuous corners (see Fig. 21).

In built-up areas the flat roof can be given the appearance of a pitched roof by giving slight texture and spraying with a dark tone of paint

one half of the surface and leaving the other half smooth (see Fig. 22).

Cast shadows must not be neglected. They can

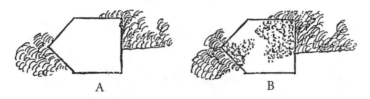

FIG. 21.—Roof of Pill-box.
A. Uncamouflaged. B. Patches of rough texture used.

often be broken in outline by placing objects such as boards or branches on the roof and allowing them to protrude slightly over the edge. Turf or rubble piled unevenly on the roof will

FIG. 22.—Roof of Pill-box.
A. Painted all over. B. Divided to give appearance of pitched roof.

have the same effect, causing irregular texture and outline (see Fig. 23).

Silhouette Boards. When a pill-box is placed against an irregular background it is sometimes useful to break up the straight lines of its walls

and roof and also the shadow cast by it by attaching boards along the angles. These boards can be given an irregular edge suitable to the

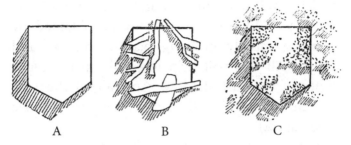

FIG. 23.—Cast shadows from Pill-boxes seen from the Air.

 A. Uncamouflaged.
 B. Outline broken by objects protruding over edges.
 C. Surfaces of roof and ground broken by patches of heavy texture.

background and painted so as to appear to be part of the irregular shape of the camouflaged pill-box (see Fig. 24).

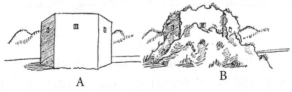

FIG. 24.

 A. Pill-box uncamouflaged.
 B. Use of silhouette boards and mounding.

Mounding. A pill-box can sometimes be partially hidden and protected by mounding up to the loop-holes. If the position is sited in rough

ground the mounding should be irregular in shape and its surface kept rough. It will probably be an advantage to spread the mound widely and unevenly around the base of the pill-box. Additional cover may be obtained by planting rapidly growing plants, creepers and weeds. All this will help to break up the regularity of the cast shadow, especially if the roof has been treated with turf as suggested above (see Fig. 24).

Rubbish. It may be possible in certain surroundings such as industrial areas or a farmyard to conceal a pill-box among rubbish by piling scrap iron or old pieces of carts or agricultural instruments over and around it to make the position look like an ordinary rubbish heap.

It is most important naturally to *avoid inflammable materials* such as hay, straw, faggots, etc.

Siting

As we have said above the camouflage of a pill-box will be determined very largely by its siting. It is often possible to conceal a position behind a wall or a hedge. In which case, probably only the loop-holes and the roof will need attention. When this can be done it is a much more satisfactory solution than building a position so that it can obviously be seen and then

setting to work to camouflage it. Other simple methods are to use hoardings, posters or trellis work.

Bluff. In cases where a pill-box has been sited at a vital point—on a bridge or somewhere where concealment is impossible, the actual presence of the pill-box underneath may be made to appear inconspicuous by the use of strong contrasts such as a poster or chequered black-out painting which inevitably draws the attention. This is the same type of bluff that we noticed when considering the eye spots on the wings of butterflies.

When, however, concealment is out of the question, the following suggestions may be useful.

Ingenious fakes such as pill-boxes, roofed and painted to look like bookstalls, covered bus stops, cafés, etc., can be constructed. In many cases they are an excellent though somewhat elaborate solution. But great care must be taken to make them look really effective from any reasonable distance and it is obviously dangerous to repeat the same solution more than once within the same area. Another danger of a different kind is that ingenious fakes of this type excite public comment, whereas the purpose of camouflage of fixed positions is that they should pass unnoticed.

A point to remember is that it is usually better

to *merge* a pill-box into its surroundings by mounding, screening or suitable painting so that its exact position is ill defined, rather than letting it stand out as an isolated target, which will often happen if it has been disguised as, say, a petrol station or a bookstall however realistically this may have been done.

Badly sited pill-boxes in obvious positions such as those sited close to a road block, against the skyline or anywhere where the enemy is certain to expect them, can be used as dummies (see above).

Sandbags

Sandbags reveal inevitably that something, probably a defensive position, is seeking protection. They are highly conspicuous because of their characteristic shape when new and far worse when they have become bleached by exposure. Hence, wherever possible, they should be covered with an outer skin. This may consist of boards, bricks, rubbish, brush wood, or painted sacking, according to the surroundings. If this is impossible, they should at least be painted with creosote, solignum or other preservatives which tone down their natural colour. Otherwise breastworks and pill-boxes after a few months of exposure, as the sandbags bleach, are

liable to become genuine whited sepulchres. Sandbags which are used as parapets for trenches can be just as serious, from the point of view of giving away a position, as spoil. This can be readily seen in photographs taken from the air of the trenches in France in the last war. However, in this case it may be possible to cover them with turf or nets. Another method of concealing sandbags is to use tar which, while still wet, should be covered with earth, grit or rubbish. Slaked lime added in the proportion of one to two lbs. to each gallon helps to reduce the shine and the danger of flow in hot weather.

Loop-holes

It is well known that loop-holes should always appear dark from the exterior, otherwise a man behind the loop-hole will be seen silhouetted against the light. If there is no other means of obtaining darkness a curtain can be hung behind his head.

Paint. Loop-holes can sometimes be concealed by a black painted patch or streak similar to the eye streak to be found in nature or even by a confusing chequered pattern such as is frequently used for black-out purposes (see Fig. 25).

Loop-holes in brick and concrete walls can be very well concealed with a gauze flap attached to a

frame hinged at the bottom and painted to imitate the surface of the wall. If gauze, per-

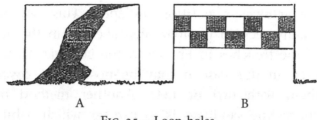

FIG. 25.—Loop-holes.

A. Concealed by painted "eye streak."
B. Concealed in chequered black-out pattern.

forated zinc or even loosely woven hessian are used they will not seriously impede vision or firing from within the post. They can be lowered

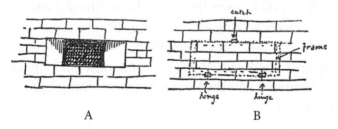

FIG. 26.—Loop-hole in Wall.

A. Uncamouflaged. B. Covered with gauze flap.

if necessary by releasing a catch. They require, however, constant maintenance (see Fig. 26).

Loop-holes in Sandbags. In some cases in towns where there are already large quantities of sand-

bags for the protection of property, it may not be so important to conceal a sandbag position. The Loop-hole, however, will need special attention since, owing to the bulging shapes of the sandbags, a flat gauze flap cannot be used. However, a false sack can be constructed with small mesh rabbit wire and covered with hessian so as to match up exactly from the exterior in colour and size with the sandbags. In cases where the loop-hole is particularly large, the flap may have to resemble two or more sandbags instead of one.

Loop-holes in a mounded position can be covered very effectively by small pieces of steel wool. If a string is attached to the steel wool it can be drawn into the loop-hole when it is necessary to clear it for firing.

Dummy loop-holes when used in a wall should be partially chipped out so as to give them a real shadow and then painted a mat black.

Trenches

The concealment of trenches depends very largely upon their siting. If they can be dug close under hedges, scrub or in rough ground, or made to fit in with the pattern of buildings or ditches, their concealment will be easy, provided

that care is taken to hide the spoil and disguise the tracks.

Parapet and parados in grass land can be concealed to some extent if they are adequately turfed. The parados should be given a very uneven appearance with irregular tufts of grass and weeds, so as to form a rough background to the heads of rifle-men (see Fig. 27).

If trenches have been sited in the open, for instance on the even slope of a green hill, it will be found very difficult to give them any satisfactory form of concealment, and parapet and parados, even when well turfed, will make them all the more conspicuous. If complete overhead cover can be given them in the form of nets or steel wool, there is still the problem of tracks to be overcome. It may in consequence be advisable to dispense with parapets, remove all spoil and rely on the smallness of the trench to protect it from observation from the air.

The small slit trenches without communication trenches between them which are recommended at the present time are easily concealed without overhead cover provided they are well sited in dark patches of rubbish or vegetation, all spoil removed and tracks leading to them well disguised. But it is very important to remember when manning these trenches that helmets should

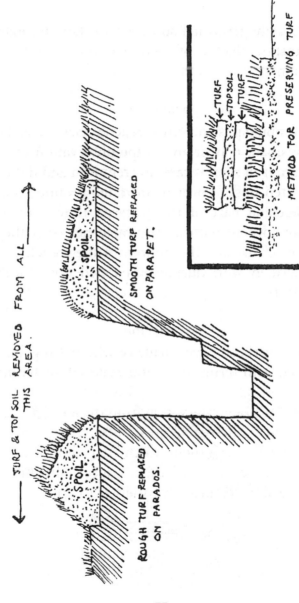

TURF & TOP SOIL REMOVED FROM ALL THIS AREA.

SPOIL

SPOIL

SMOOTH TURF REPLACED ON PARAPET.

ROUGH TURF REPLACED ON PARADOS.

TURF

TOP SOIL

TURF

METHOD FOR PRESERVING TURF

FIG. 27.—Section of Trench showing Method of turning Spoil.

77

be heavily garnished so as not to show up light against the shadow of the trench when seen from the air.

Bombing Pits

Bombing pits and cross trenches, being usually very small, may easily escape observation from the air, if all spoil is carefully removed and if they are sited under cover or in rough ground so as to become part of the pattern. They may be easily covered with a removable net or if they are in chalk soil, the bottom of the trench can be hidden with duckboards toned down with creosote.

Weapon Pits

An overhead cover made of wire netting, garnished with scrim or natural material, matching

FIG. 28.—The Spider.

A. Open. B. Folded.

with the immediate surroundings, can be con-
structed, or a garnished M.T. net set up on
a "spider" may be used. The M.T. net and
methods of garnishing will be described below.
The "spider" is a very simple device which

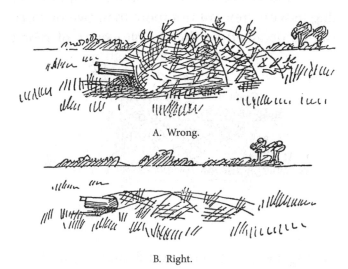

A. Wrong.

B. Right.

FIG. 29.—Weapon Pit covered with M.G. net and Spider.
A. Wrong. B. Weapon dug in and spoil removed.

can be improvised (see Fig. 28). It is made
from six-foot lengths of ¼-in. diameter steel wire,
hinged round a central bolt ; when opened its
six legs form a kind of umbrella which is strong
enough to stand up without a central support.
If the weapon pit is to be sited in the open it is

well to keep the net as low as possible so as not to attract attention from the ground and to avoid casting shadows (see Fig. 29).

Small Wire-netting Screens

Ground concealment for small weapons not dug in with crews of not more than two or three can be obtained by the use of a piece of rabbit

FIG. 30.—Small Wire-netting Screen.

netting about 2 ft. 6 in. by 4 ft. and about 1½ in. mesh set up with skewers pushed into the ground at each end. The netting should be painted and garnished with dyed hessian knots, steel wool or local rubbish. This net being easily portable and easily set up is suitable under highly mobile conditions, but care must be taken to see that the screen is in the light and that it is not silhouetted against the ground behind (see Fig. 30). Helmets should be well garnished.

Road Blocks

In most cases there is no satisfactory method of giving concealment to a road block, owing to the way in which it is bound to interfere with the natural lines of the road. The only remaining method of camouflage, therefore, is to resort to bluff. Screens of hessian or other material may be kept in readiness to be placed across the road in several places with the purpose of hiding the road blocks and bluffing the enemy so that the actual position is unknown to him.

It should be possible to gain a very real advantage by screening a road block in this way, because it will hide the exact points at which a tank would want to aim its shells in order to demolish the block. Tanks can only carry with them a limited amount of ammunition, and it should be our aim to make them waste as much as possible on useless shooting. On the other hand, if the tank chooses to go round the screen we shall have succeeded in forcing it into the ditch and gained that way.

Nevertheless a degree of concealment which is worth attempting can be attained by toning down the staring whiteness of concrete blocks or dragon's teeth with paint.

MATERIALS AND EQUIPMENT

Nets

FULL instructions for the use of nets for transport or machine-gun posts are given in the M.T. Pamphlet No. 46, Parts 1 and 2, and also the posters designed by the Camouflage Centre. These few additional remarks may be useful

The machine-gun or M.T. net (14 ft. by 14 ft.) can be garnished with scrim, i.e. strips of dyed hessian about 2 in. wide, dyed in various shades of green and brown. A variety of patterns may be used. The important point to remember being that the net should not be filled completely with scrim especially towards the edges. If the scrim is thinned out towards the edges this will avoid hard shadows being cast by the net and allow it to merge more easily into its surroundings (see Fig. 31).

N.B. These nets must not be fired through with a machine-gun or they will burn. They must be looped up over the barrel when the gun is in action.

Shrimp netting and heavy small mesh netting is

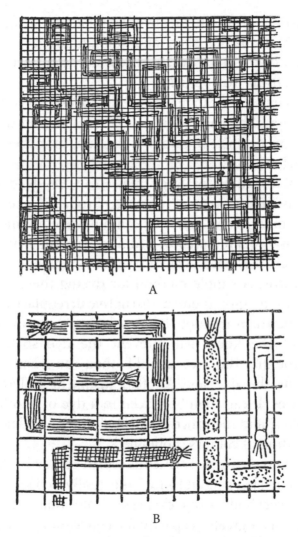

A

B

FIG. 31.—Garnishing of Machine-gun or M.T. net

A. A portion of the net. Scrim tapered off towards the edge.
B. Method of weaving garnish into net.

particularly useful for covering reflecting surfaces such as metal, glass and human faces. Large nets of this type when procurable can be used effectively over vehicles.

Wire netting can make excellent overhead cover. It should be painted, if new, and garnished with scrim, patches of coloured hessian, branches or steel wool.

Net curtains of large mesh can be dyed or painted in irregular patches. Probably one of the most useful pieces of camouflage equipment is two square yards of ordinary curtain netting which has been dyed in yellowish greens and browns. A simple method for dyeing these nets so as to give them a disruptive irregularity is to tie them in knots before placing them in the dye. The knots will prevent the dye soaking through. The net should then be removed from the dye and knotted again in different places. It can then be placed in a dye of another colour and the process repeated until a sufficient mixture of colours is obtained.

There is a point which is worth remembering when using nets and which is actually well known to everybody from experience, i.e. that a light net has a greater capacity for concealment of an object placed in shadow behind it than a dark net. The ordinary white net window curtain is

an example of this. It prevents anybody seeing into the room when the interior of the room is darker than outside. This effect will not be so easily obtainable with a dark net or if the interior of the room were lighter than it is outside. Hence we may deduce from this that a light net has a better capacity of concealment than a dark net and that it will hide a dark object more easily than a light one. In other words garnished nets and curtain nets can afford to be slightly lighter in tone than would be expected at first sight.

Rubbish

For the Home Guard who must frequently fall back on improvisation to solve their problems, rubbish of all sorts is one of the most useful and most readily obtainable materials. Not only is it possible to use rubbish as a covering for a small position but also it provides the kind of irregular background against which it is easy to hide. In towns or factory areas scrap, slag heaps or rubble can often be used in this way, whereas in the country old carts, agricultural instruments, logs and even manure heaps, provided they are only for temporary use, make excellent cover. In places that have been bombed there is usually an abundance of rubble, in fact the more destruction the enemy manage to inflict the more

material of this sort we shall acquire and the easier concealment will become.

Natural Material

In the country, in summer particularly, the use of natural material for camouflage offers great advantages, but we must not forget certain disadvantages also. In selecting branches, grass or scrub, we must first consider the background against which they will be seen. It is of little use to cover a position which might be in a cornfield, with holly branches. But whenever possible, in order to avoid the necessity of continual renewal of withering leaves, evergreens such as pine, holly, gorse or heather or small foliage that does not wither as quickly as big juicy leaves, should be chosen. When gathering material of this sort, it is as well to use discretion so as not to destroy cover which might have served a useful purpose. It is better on the contrary to use branches which may have to be cleared in order to open a field of fire, thus killing two birds with one stone. It is worth remembering that most leaves are considerably lighter in tone on the underside and that in laying branches over a position or in placing leaves in a net over a helmet a false effect will be obtained if they are not kept the right way up.

Chapter IX

INDIVIDUAL CAMOUFLAGE

In considering observation from the air we have been insisting chiefly on the importance of symptoms rather than of individuals. But we must remember that it is the individual that makes up the mass and that even from the air details, particularly when multiplied, are often important. Helmets, faces and small articles of equipment are often extremely good targets for the dive bomber. We have also close observation from the ground to contend with, so that there is every reason for us to give serious attention to the question of individual camouflage and personal concealment. There is no doubt that the British should be extremely apt at this art. Nearly everyone has one day or another shown his interest in bird watching, fishing, stalking rabbits or poaching, and of all these pursuits probably poaching is the best education for personal concealment, because it requires not only a keen eye for nature but also a sense of how to remain unobserved by the gamekeeper.

The Home Guard scout needs exactly these qualities. Our native country also, almost without exception, provides us with plenty of good cover. The irregularity of its roads and hedgerows, the large quantity of trees and the abundance of vegetation give us just the background we need for good concealment, provided we are familiar with our own neighbourhoods and understand how to use the cover that they afford.

Faces and Hands

Faces and hands when left uncovered are remarkably conspicuous, particularly against the prevalent green of the English landscape. They are also clearly visible from the air when men look up to gaze at an aeroplane. Even at night they are often the only parts of a man that can be seen at all. The Home Guardsman may have many dangerous tasks to accomplish but there is little doubt that from his own point of view the most dangerous thing that he can carry about him is his own naked face. There are various methods of getting over this difficulty Perhaps the simplest is to discolour all flesh that is visible with soot, mud, burnt cork or green Blanco. A mixture of soot and flour will make a good paste which sticks to the skin. By some who live in country districts cow-dung has

been advocated, and for those who have the courage to use it, it can be highly recommended in spite of its unpleasantness, since it retains good colour and texture when dry. Another method is to cover the head with a heavy close-mesh net, such as the shrimp net or a hessian hood. Eye-holes can be made by pulling out threads from the hessian or by inserting patches of gauze or loosely woven netting. The advantage of using a net or hood is that it also hides eyeglasses. Hands can be hidden most easily by discolouring or by gloves. Large mittens made of coloured canvas netting can be attached to the back of the hands, leaving the fingers free.

Helmets

The helmet, it must be remembered, is a top surface and in accordance with nature's methods it must be kept dark. A good coat of mat paint, containing as much grit as possible, can be applied, using if desired two tones to form a disruptive pattern. A temporary effect of this kind can be obtained by using on one part khaki blanco and boot black or cow-dung on the other. But this alone is hardly sufficient and it is usually advisable to add a net. Nets for helmets can be either of the shrimp-net type, in which case, if they are fitted with elastic,

small leaves and twigs can be stuffed inside them so as to break up the characteristic shape of the helmet. If a larger mesh is used it should be easy to insert small leaves, grass or tufts of scrim or painted sacking. Certainly it would be in-

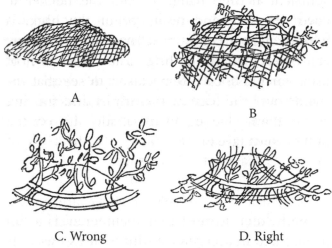

C. Wrong D. Right

FIG. 32.—Methods of camouflaging Helmets.

A. Small mesh net stuffed with garnish underneath.
B. Net garnished with leaves or scrim.
C. and D. Branches and grass held on by band fixed to helmet.

advisable to add more garnish than is strictly necessary. It should never be allowed to form plumes, towering above the head which may give their wearer away by movement. Whatever garnish is used must be suitable to the immediate surroundings. The purpose in view is merely

to alter the texture and the characteristic out-
line of the helmet to suit the background. Pieces
of tennis net, fruit net, the ordinary net used
for ferreting or curtain nets can be fitted out in
this way. It is often an advantage to leave
sufficient netting hanging from the helmet to
cover the face and respirator or the back. A
wire or a ring cut from a large-size inner tyre
can be secured to the helmet and used to hold
leaves or grass, care being taken to see that the
twigs cover the edge of the helmet and the face
rather than allowing them to stick up on top
of the crown (see Fig. 32).

Net Curtains

Net curtains as described above are an ex-
tremely useful piece of equipment for every scout
or patrol. Two yards of this netting suitably
dyed could be carried by every man. They are
rapidly adjusted to cover the back, the helmet
or the face. It is often the back which is most
exposed and at the same time, most easily
neglected (see Fig. 33).

Respirator Container

The respirator container at the alert position,
forms an excellent target to the enemy, its smooth
surface and rectangular shape being placed con-

spicuously on the chest. It is, however, very easy to cover it with a strip of coarse hessian with irregular patches of paint, placed diagonally

FIG. 33.—Curtain net covering Helmet and Respirator.

FIG. 34.—Respirator covered with painted hessian.

across the respirator or by a net which is long enough to cover the helmet and face as well (see Fig. 34).

The Rifle

The problem of camouflaging the rifle is to be able to hide the glint of metal, disrupt the length of the barrel and hide the sling without interfering with its mechanism or sights. One simple method is to use strips of insulating tape wound closely round the barrel. If black tape and white tape, which can be painted a suitable

colour or darkened with leaf juice, are inter-
spersed along the barrel a disruptive effect is
obtained. Sometimes a few small leaves can
also be firmly attached in this way. The red
band used to distinguish the American rifle can

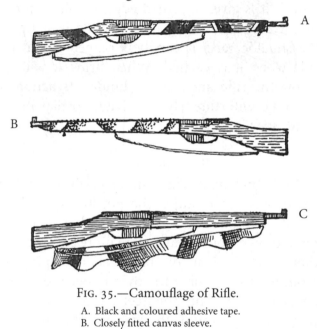

FIG. 35.—Camouflage of Rifle.
A. Black and coloured adhesive tape.
B. Closely fitted canvas sleeve.
C. Strip of painted hessian.

also be hidden without being removed. Another
method is to use a stocking or jacket of canvas
which can be pulled over the barrel and attached
with an elastic. If it is sufficiently well tailored
it will lie flat on the barrel and not interfere

with the sights. It can then be painted disruptively. A third method which is more foolproof is to use a strip of hessian which can be also painted disruptively and stretched between the top sling swivel and the sling swivel on the butt. If it is given a jagged edge, it will be useful in covering the sling when the rifle is slung on the shoulder and it can be wrapped round the rifle when it is carried. When firing it will fall below the rifle and cannot hinder its action in any way, unfortunately it is liable to flap in the wind (see Fig. 35).

Boots and Gaiters

Boots and gaiters are more easily concealed when they are muddy. The polish required for parades should at once disappear when in action. Light brown leather gaiters are more conspicuous than dark brown or black. For sniping or scouting it is possible to cover boots and gaiters entirely by placing the feet in painted sacks, tied securely round the calves. This will not only hide them, but deaden the noise of hobnails on the road. An old pair of khaki socks may serve the same purpose.

Metal Badges

Metal badges should be removed or covered with khaki blanco or mud.

Sniper Suits

Scouting and Sniping. It is possible to improvise suits which can be worn over battledress and which can be of great help to snipers or scouting patrols. Particularly in areas where overhead cover is scarce, such as the Moors or the Fen country, but it is essential to realise that these suits are not cloaks of invisibility and that any man who uses one must first learn the rules of scouting, stalking and how to use cover.

As in nature it is his behaviour against the background that will be the chief factor in helping a man to hide. Concealment can only be attained by immobility and by getting as close as possible to an object, such as the trunk of a tree, a wall, a hedge, a pile of rubbish or a rock, and uniting with its shape and shadow so that there is no chance of being silhouetted against the sky or a background with which a man is not in tone. As was seen above it is behaviour and control of tone that will enable a man to take up an advantageous position in front of cover, and to complete this a sniper suit can be a very great advantage to an observer or a sentry. There are many excellent books on this subject and the Camouflage Centre have produced admirable posters which can help

in instruction. But the best possible training is for men to try out these suits in their own neighbourhoods, getting others to watch them and criticise their behaviour since, naturally, they will not be able to see themselves. It may very likely be necessary to readjust the colour of a suit with the changes of colour brought about by the seasons. But the same rules discussed above for colour in general hold good, and it is usually possible by mixing a variety of colours in the suit to obtain an effect that has a fairly universal application. It is not difficult, after a little training, to be able to pick out a piece of cover which has suitable colour and tone for any particular suit.

Since observation and attack in modern war must be expected from any direction, sniper suits which cover a man completely will give him concealment from the rear and from above as well as from frontal attack.

There is every advantage to be gained by giving these suits plenty of variety in design. Uniformity is likely to aid recognition by the enemy once he knows the kind of shape or colour to look for. Also in nature every object contains a variety of colours and a suit of many colours will have a wider choice of backgrounds.

Essential points necessary for all sniper suits :

1. *Mobility.* The suit must be designed in such a way that it does not impede a man's movement, nor get caught up easily in branches and brambles. He must be able to move rapidly and at the right moment. It is for this reason that on the whole hessian suits are more suitable than nets.

2. *Mat surface.* In order to obtain a surface from which there are no reflections a material such as loosely woven packing hessian or bath-towelling can be painted with mat paint. There are a great many paints that will serve this purpose—ordinary oil paint, diluted in turpentine, oil-bound distemper applied with petrifying liquid, wool grease lanoflage paint and many others.

3. *Colour.* If colours are applied in a disruptive design, with a little experience it will be possible to find a mixture of colours, consisting chiefly of browns, yellowish greens, dull reds and black, which will fit in with a large variety of backgrounds. Again the one colour to avoid is blue and anything verging upon it.

4. *Proficiency in scouting and stalking for the wearer.* See pages 36–42.

There are many different types of sniper suits that can be easily improvised without great expense. The following are some of the most simple to make up (see Fig. 36).

Boiler suits or Denim suits can be painted with disruptive patterns with mat paint, using the original colour of the suit as one of the shades.

Overcoat suits with cowls can be made up of aeroplane cloth or bath-towelling and painted suitably. Gauze eye-holes can be fitted. There is, however, the disadvantage that this close-fitting cowl will cause discomfort to the wearer in hot weather.

Hessian suits made of coarse packing hessian or sacking are cheap and easy to make up. They can be very effective and are probably the most suitable for the Home Guard. They can be designed with loose-fitting trousers, like cowboy's chaps, or bags which enclose boots and gaiters. If the seams are turned outwards, a jagged edge can be obtained. In painting them disruptive patterns will be found to be useful and as in nature the upper surfaces, such as the back of the hood, shoulders and back may be kept darker in tone than the front. It is some-times a good plan to make the pattern cut across the back and the legs, as this part is likely to be most visible when a man is lying on the

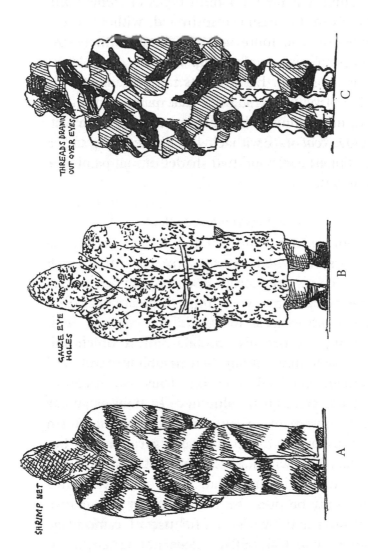

SHRIMP NET

GAUZE EYE HOLES

THREADS DRAWN OUT OVER EYES

FIG. 36.—Sniper Suits.

A. Painted boiler suit. B. Overcoat suit. C. Hessian suit.

ground, but for the front of the suit which will be visible if a man is standing with his back to a tree trunk, a more vertical pattern which cuts diagonally across the body will be more in keeping. It is said that a trained Sapper should be able to make up a suit of this type in ten minutes. All he requires to do so is 11 ft. of hessian 6 ft. wide, scissors or a jack knife, strong thread, a packing needle and two shades of mat paint (see Fig. 37).

The Phantom Platoon

For sentries or snipers, the sniper suit disguise is certainly a help, but for a mobile patrol which may be moving across open country or among the streets of a town, similar disguises offer even great advantages. It should be possible, with training, to organise mobile patrols which will be able to move about their neighbourhoods and remain practically invisible. They will in consequence be of great value in operations as guides and observers. They will be able to form ambushes for the enemy and surprise and bewilder him without him being able to tell from where he is being attacked or observed. This can only be done by constant and imaginative training and by the skilful use of camouflage equipment. Camouflage does not usually need

FIG. 37.—Instructions for cutting Hessian Sniper Suit.

complicated and expensive equipment. Some of its most outstanding successes have come about through ingenious improvisation. The example of Lawrence of Arabia, who improvised a desert camp out of branches and blankets which completely deceived the Turks, is one of a thousand instances of this kind of ingenuity. It is useless in warfare to be merely brave, if bravery means presenting oneself as a useless target to the enemy. It is far better to employ intelligence and concealment, so as to induce *him* to present a target. A man who is well concealed can bide his time, watch for the enemy to expose himself and hold his fire until his target is sufficiently close to make sure of it. In this way the Home Guard may be able to destroy the invader without even allowing him the chance to hit back. By good concealment it will greatly augment its value as a fighting force. Camouflage is no mystery and no joke. It is a matter of life and death—of victory or defeat.